The Ceremonial Funeral of Baroness Thatcher

17TH April 2013

First published in 2013 by
Unicorn Press Ltd
66 Charlotte Street
London W1T 4QE

www.unicornpress.org

For Sarah, James and Harry.

ISBN 978 1 9065 09361

1 3 5 7 9 10 8 6 4 2

Cover design by Camilla Fellas
Repro by XY Digital, London
Printed in China for Latitude Press Ltd

The Ceremonial Funeral of Baroness Thatcher

17th April 2013

A Watercolour Sketchbook
by Thomas J. Plunkett,
President of the
Royal Watercolour Society

With the Tribute by
The Rt. Revd. and Rt. Hon.
Richard Chartres KCVO DD FSA,
Bishop of London

Unicorn Press Ltd
London

The Bishop of London's Address at Baroness Thatcher's Ceremonial Funeral

After the storm of a life lived in the heat of political controversy, there is a great calm.

The storm of conflicting opinions centres on the Mrs Thatcher who became a symbolic figure – even an 'ism'. Today the remains of the real Margaret Hilda Thatcher are here at her funeral service. Lying here, she is one of us, subject to the common destiny of all human beings.

There is an important place for debating policies and legacy; for assessing the impact of political decisions on the everyday lives of individuals and communities. Parliament held a frank debate last week – but here and today is neither the time nor the place. This, at Lady Thatcher's personal request, is a funeral service, not a memorial service with the customary eulogies.

At such a time, the parson should not aspire to the judgments which are proper to the politician; instead, this is a place for ordinary human compassion of the kind that is reconciling. It is also the place for the simple truths which transcend political debate, and above all it is the place for hope.

It must be very difficult for those members of her family and those closely associated with her to recognise the wife, the mother and the grandmother in the mythological figure. Our hearts go out to Mark and Carol and to their families, and also to those who cared for Lady Thatcher with such devotion especially in her later years.

One thing that everyone has noted is the courtesy and personal kindness that she showed to those who worked for her, as well as her capacity to reach out to the young and often also to those who were not, in the world's eyes, 'important'.

The letter from a young boy early on in her time as Prime Minister is a typical example. Nine-year-old David wrote to say: 'Last night when we were saying prayers, my daddy said everyone has done wrong things except Jesus and I said I don't think you have done bad things because you are the Prime Minister. Am I right or is my daddy?'

Now perhaps the most remarkable thing is that the Prime Minister replied in her own hand in a very straightforward letter which took the question seriously. She said: 'However good we try to be, we can never be as kind, gentle and wise as Jesus. There will

be times when we do or say something we wish we hadn't done and we shall be sorry and try not to do it again.'

She was always reaching out, she was trying to help in characteristically un-coded terms. I was once sitting next to her at some city function and in the midst of describing how Hayek's *The Road to Serfdom* had influenced her thinking, she suddenly grasped my wrist and said very emphatically, 'Don't touch the duck paté, Bishop – it's very fattening.'

She described her own religious upbringing in a lecture she gave in the nearby church of St Lawrence Jewry. She said: 'We often went to church twice on a Sunday, as well as on other occasions during the week. We were taught there always to make up our own minds and never take the easy way of following the crowd.'

Her upbringing of course was in the Methodism to which this country owes a huge debt. When it was time to challenge the political and economic status quo in nineteenth-century Britain, it was so often the Methodists who took the lead. The Tolpuddle Martyrs, for example, were led not by proto-Marxists but by Methodist lay preachers.

Today's first lesson describes the struggle with the principalities and powers. Perseverance in struggle and the courage to be, were characteristic of Margaret Thatcher.

In a setting like this, in the presence of the leaders of the nations, or any representatives of nations and countries throughout the world, it is easy to forget the immense hurdles she had to climb. Beginning in the upper floors of her father's grocer's shop in Grantham, through Oxford as a scientist and, later, as part of the team that invented Mr Whippy ice cream, she embarked upon a political career. By the time she entered Parliament in 1959 she was part of a cohort of only 4% of women in the House of Commons. She had experienced many rebuffs along the way, often on the shortlist for candidates only to be disqualified by prejudice against a woman – and, worse, a woman with children.

But she applied herself to her work with formidable energy and passion and continued to reflect on how faith and politics related to one another.

In the Lawrence Jewry lecture she said that: 'Christianity offers no easy solutions to political and economic issues. It teaches us that we cannot achieve a compassionate society simply by passing new laws and appointing more staff to administer them.'

She was very aware that there are prior dispositions which are needed to make market economics and democratic institutions function well: the habits of truth-telling, mutual

sympathy, and the capacity to co-operate. These decisions and dispositions are incubated and given power by our relationships. In her words: 'The basic ties of the family are at the heart of our society and are the nursery of civic virtue.' Such moral and spiritual capital is accumulated over many generations but can be easily eroded.

Life is a struggle to make the right choices and to achieve liberation from dependence, whether material or psychological. This genuine independence is the essential pre-condition for living in an other-centred way, beyond ourselves. The word Margaret Thatcher used at St Lawrence Jewry was 'interdependence'.

She referred to the Christian doctrine, 'That we are all members one of another, expressed in the concept of the Church on earth as the Body of Christ. From this we learn our interdependence and the great truth that we do not achieve happiness or salvation in isolation from each other but as members of society.'

Her later remark about there being no such thing as 'society' has been misunderstood and refers in her mind to some impersonal entity to which we are tempted to surrender our independence.

It is entirely right that in the Dean's bidding there was a reference to 'the life-long companionship she enjoyed with Denis.' As we all know, the manner of her leaving office was traumatic but the loss of Denis was a grievous blow indeed, and then there was a struggle with increasing debility from which she has now been liberated.

The natural cycle leads inevitably to decay, but the dominant note of any Christian funeral service, after the sorrow and after the memories, is hope.

It is almost as perplexing to identify the 'real me' in life as it is in death. The atoms that make up our bodies are changing all the time, through wear and tear, eating and drinking. We are atomically distinct from what we were when we were young. What unites Margaret Roberts of Grantham with Baroness Thatcher of Kesteven? What constitutes her identity? The complex pattern of memories, aspirations and actions which make up a character were carried for a time by the atoms of her body, but we believe they are also stored up in the Cloud of God's being.

In faithful relationships, when two people live together, they grow around one another and the one becomes a part of the other. We are given the freedom to be ourselves and, as human beings, to be drawn freely into an ever closer relationship with the Divine nature. Everything which has turned to love in our lives will be stored up in the memory of God.

First there is the struggle for freedom and independence and then there is the self-giving and the acceptance of inter-dependence.

In the gospel passage read by the Prime Minister, Jesus says 'I am the way, the truth, and the life.' That 'I am' is the voice of the Divine being.

Jesus Christ does not bring information or mere advice but embodies the reality of Divine love. God so loved the world that He was generous: He did not intervene from the outside but gave Himself to us in the person of Jesus Christ, and became one of us.

What, in the end, makes our lives seem valuable after the storm and the stress has passed away and there is a great calm? The questions most frequently asked at such a time concern us all. How loving have I been? How faithful in personal relationships? Have I discovered joy within myself, or am I still looking for it in externals outside myself?

Margaret Thatcher had a sense of this, which she expressed in her address to the general assembly of the Church of Scotland when she said: 'I leave you with the earnest hope that may we all come nearer to that other country whose ways are ways of gentleness and all her paths are peace.'

T.S. Eliot, in the poem quoted in this service sheet, says: 'The communication / Of the dead is tongued with fire beyond the language of the living.'

In this Easter season death is revealed, not as a full stop but as the way into another dimension of life. As Eliot puts it: 'What we call the beginning is often the end / And to make an end is to make a beginning. / The end is where we start from.'

Rest eternal grant unto her O Lord and let light perpetual shine upon her.

The Rt. Revd. and Rt. Hon. Richard Chartres KCVO DD FSA,
Bishop of London
April, 2013

LIST OF SKETCHES

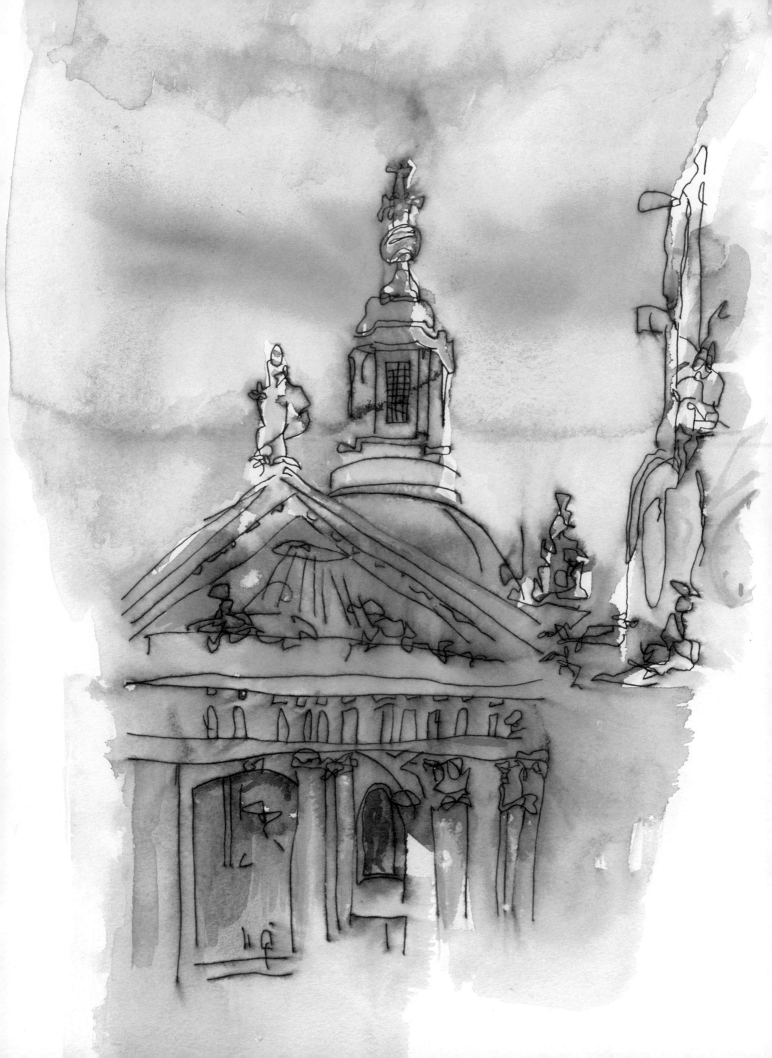

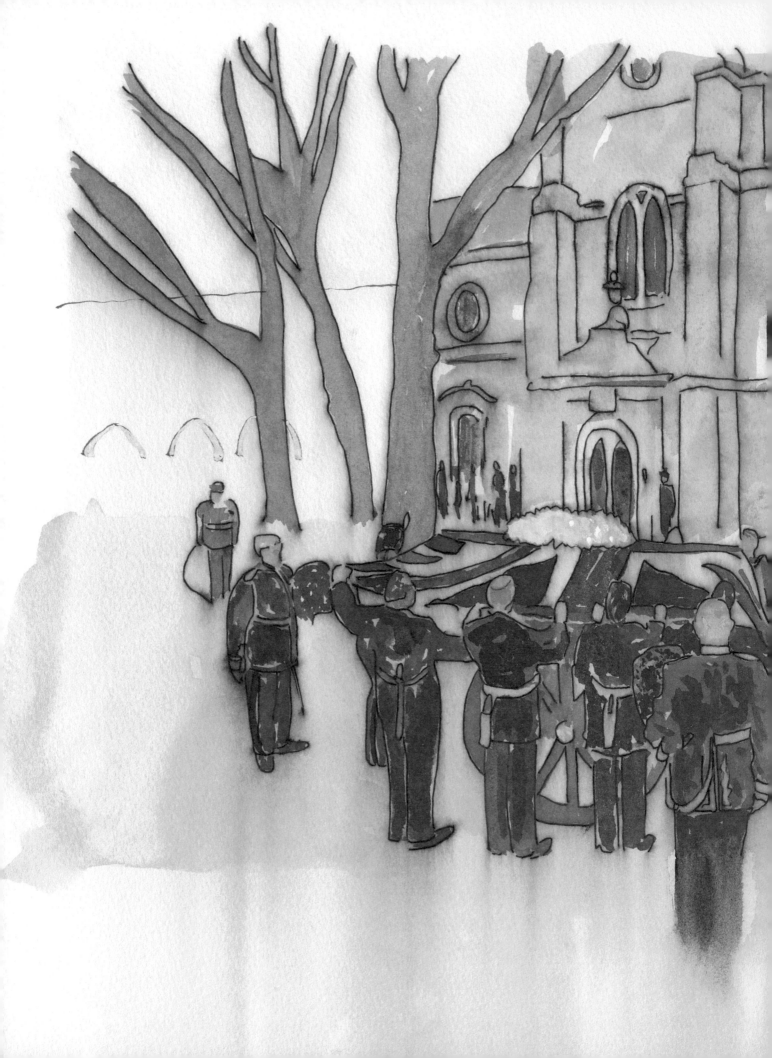

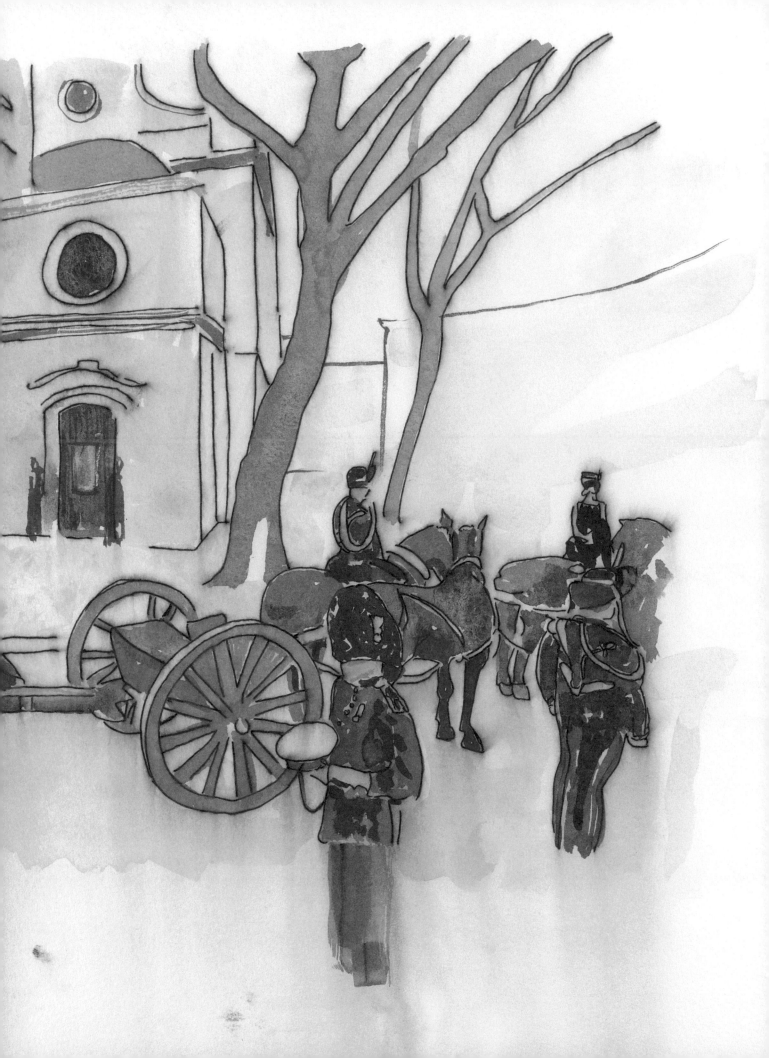

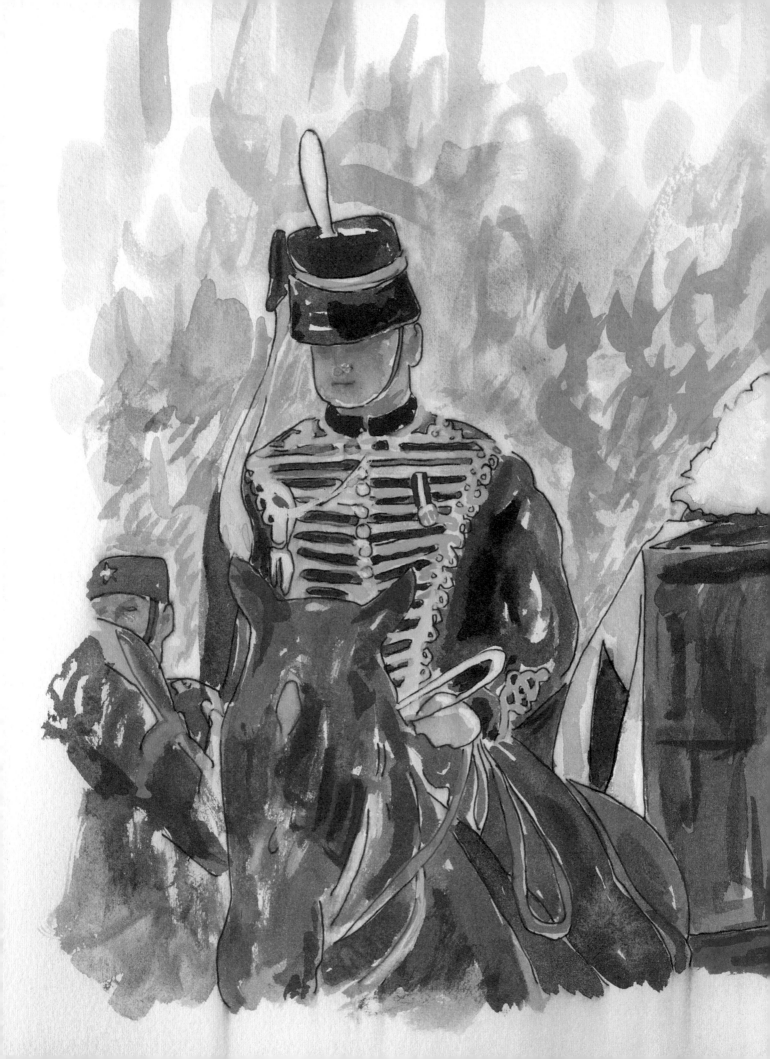

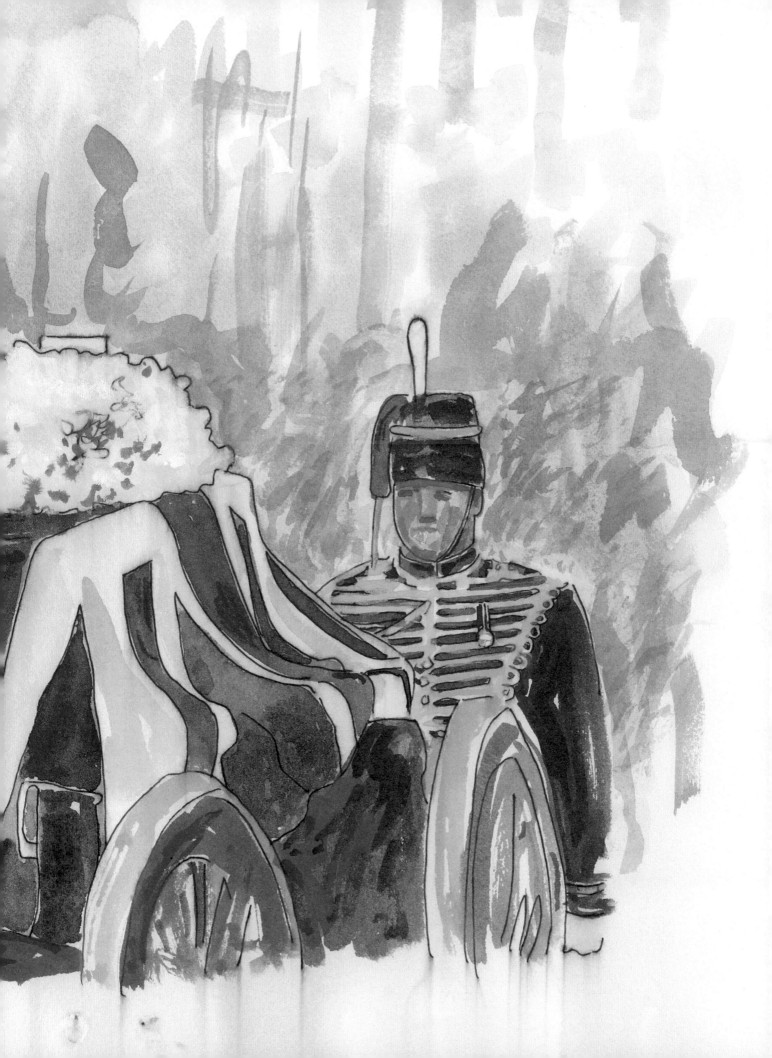

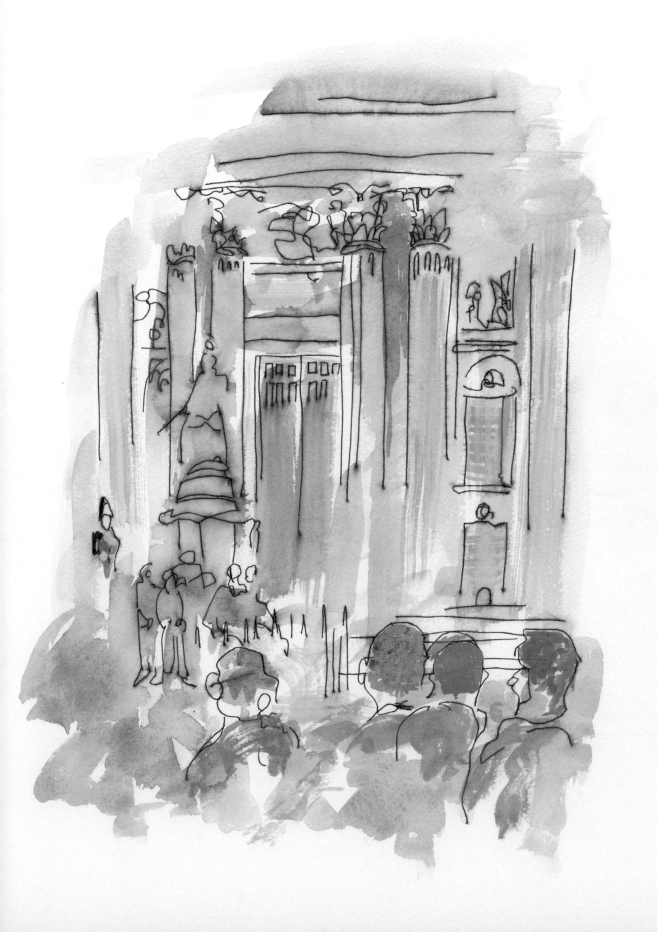

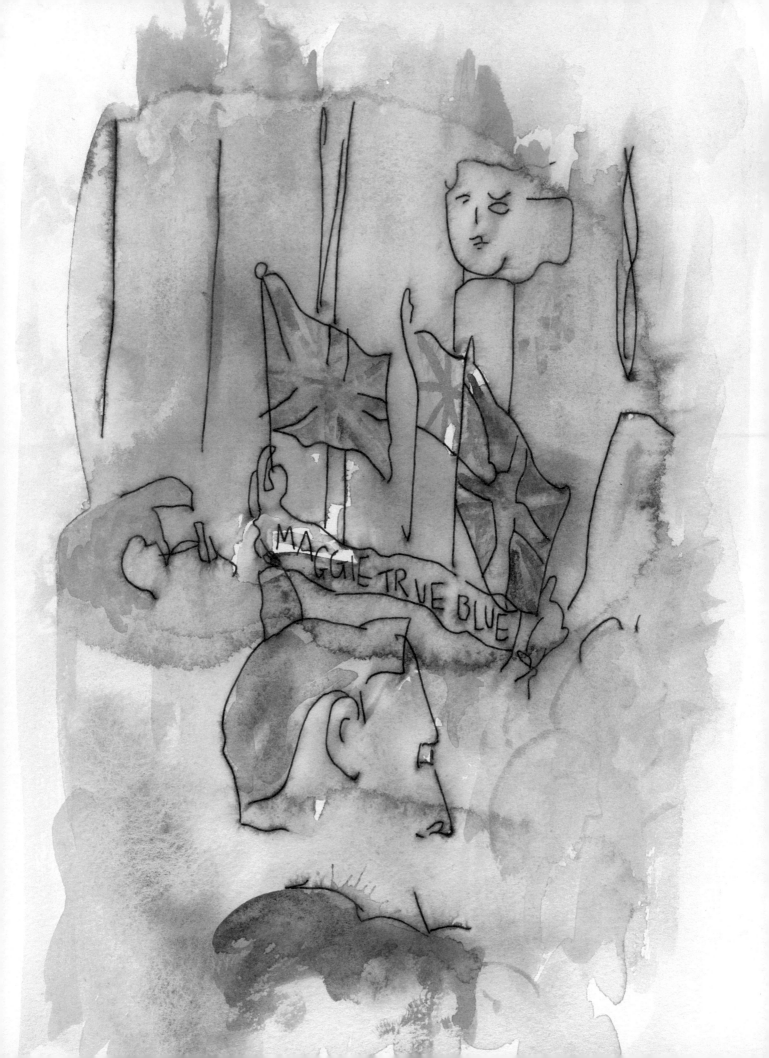

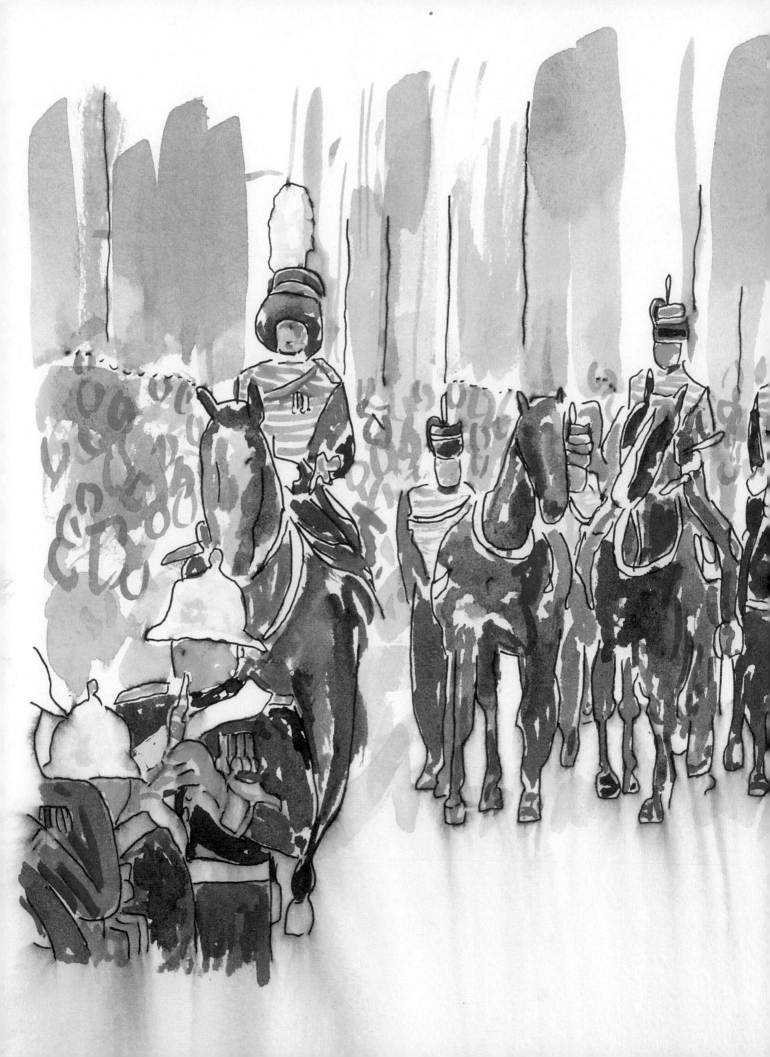

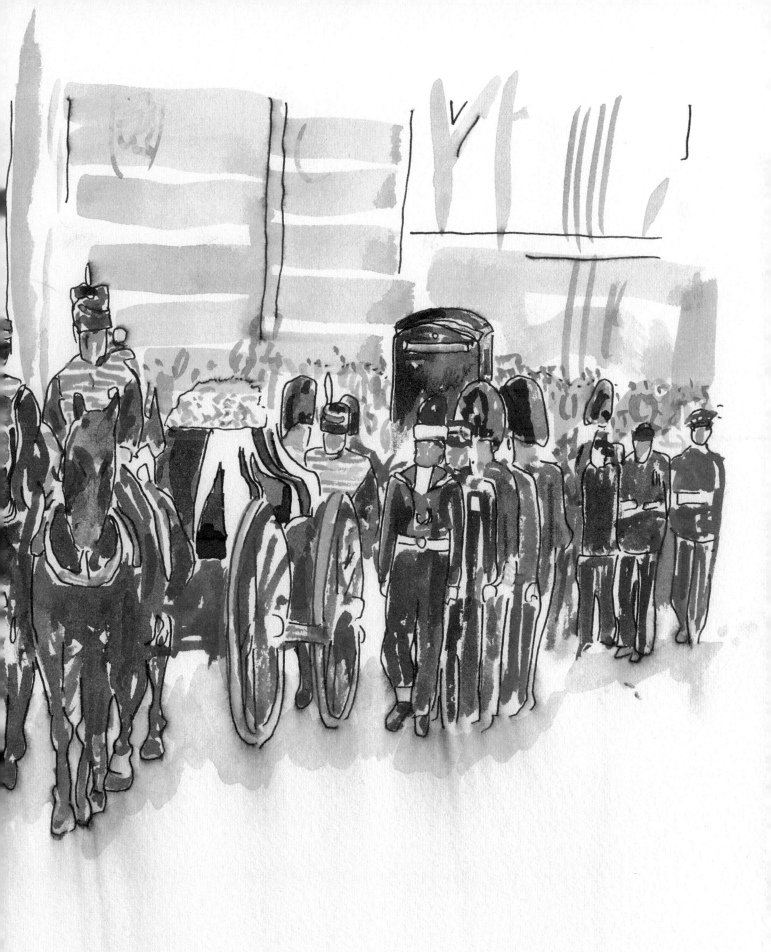

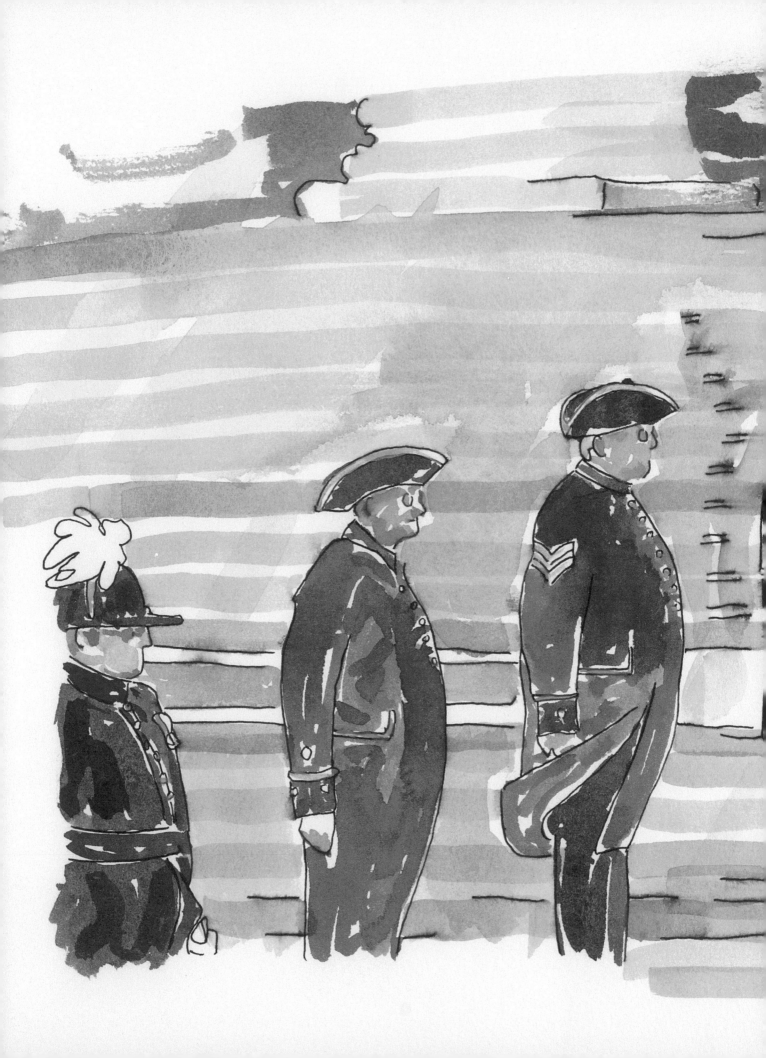

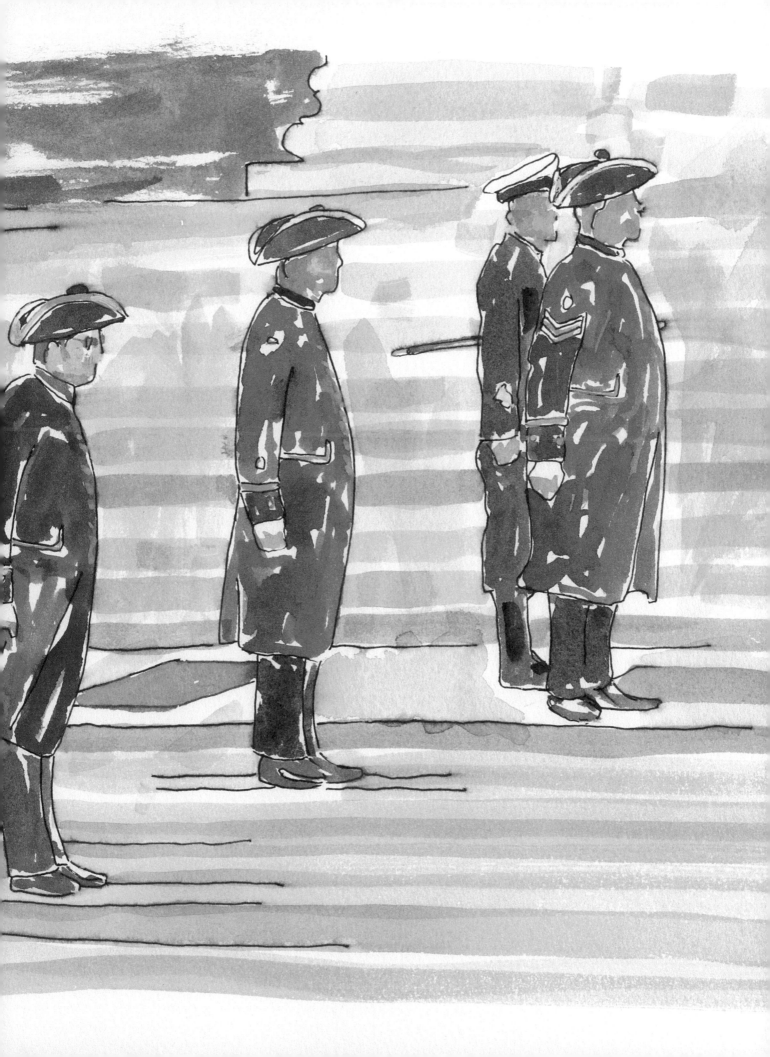

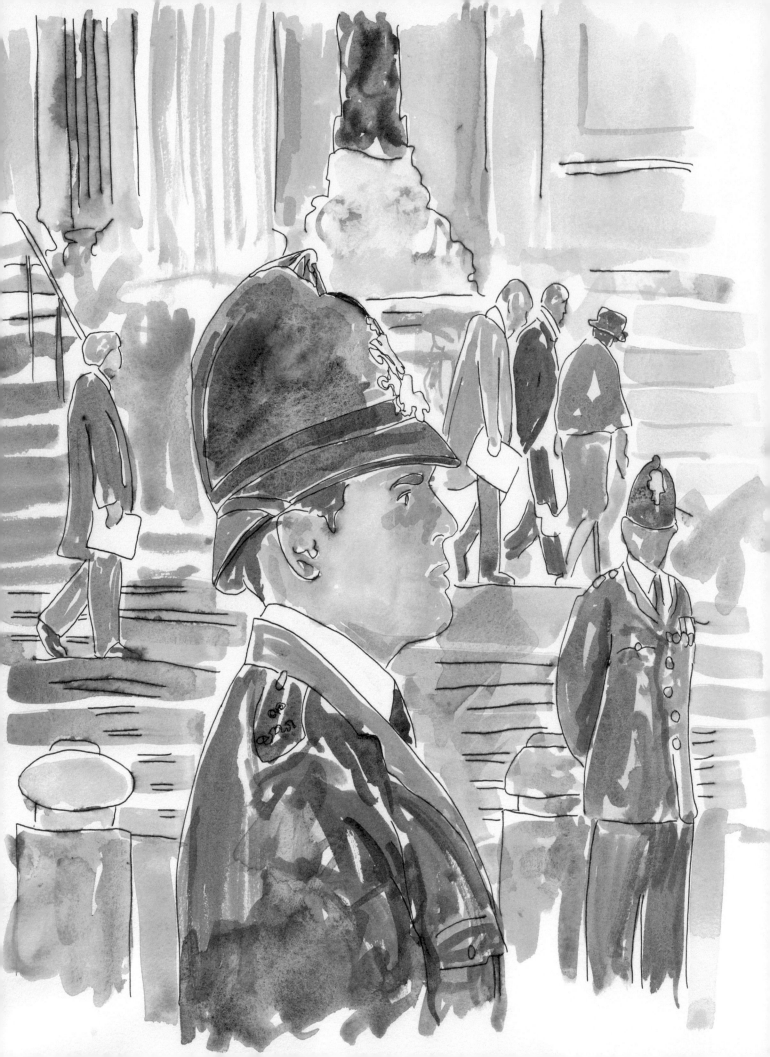

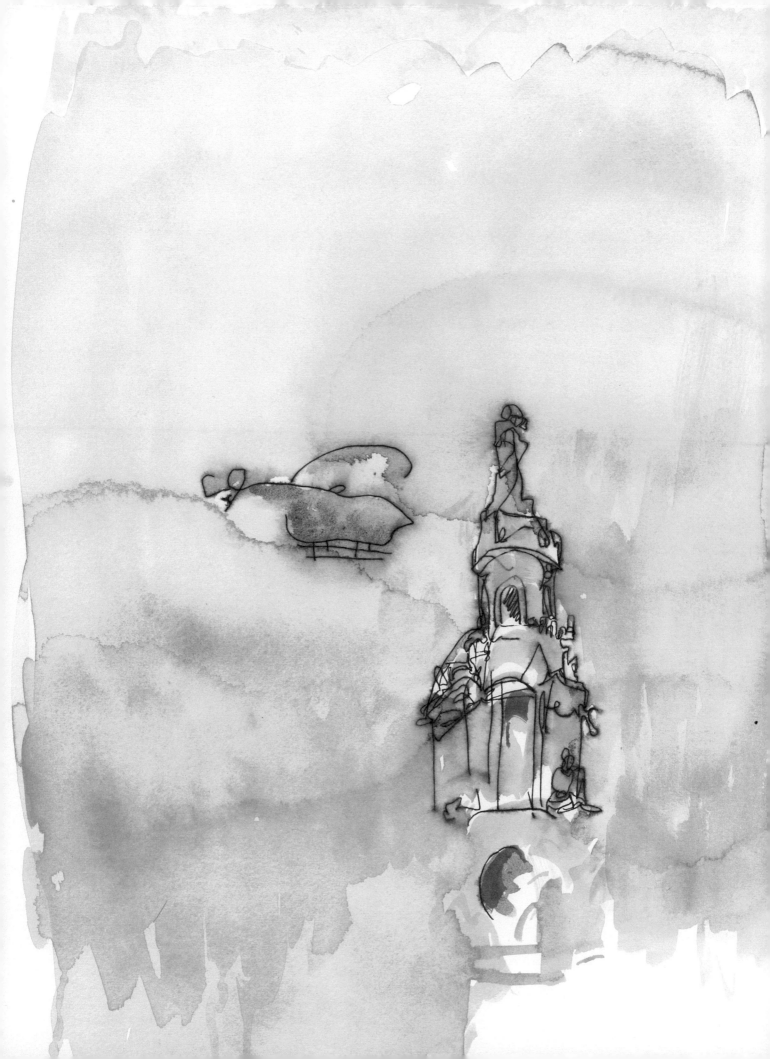

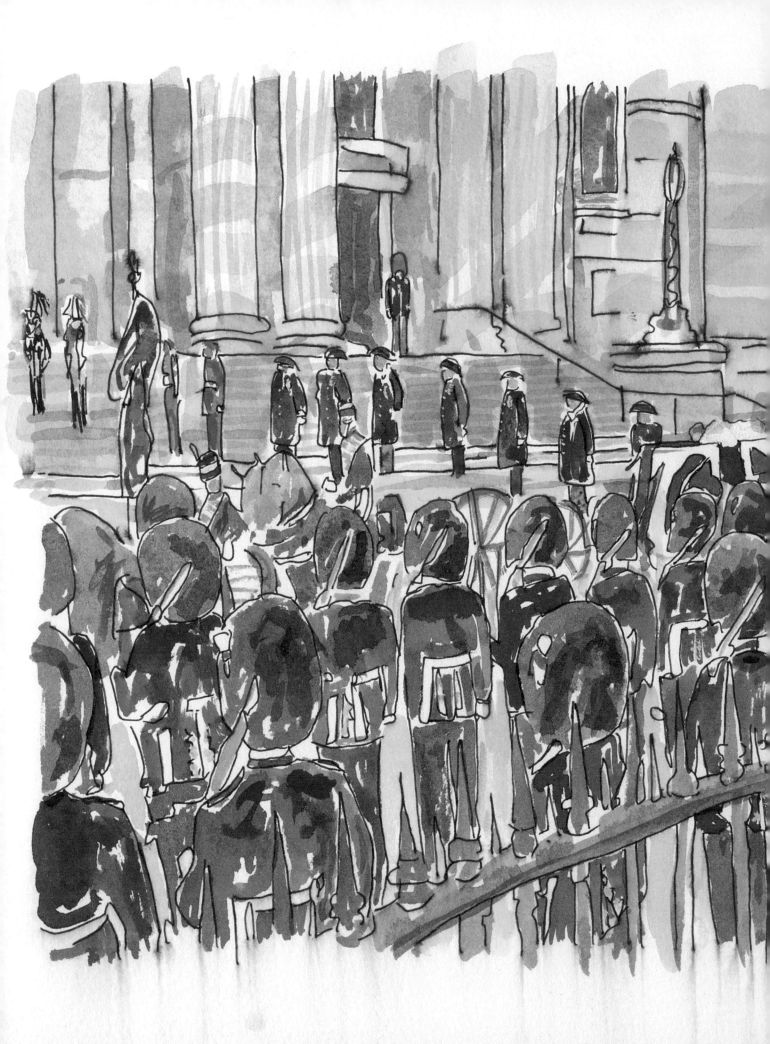

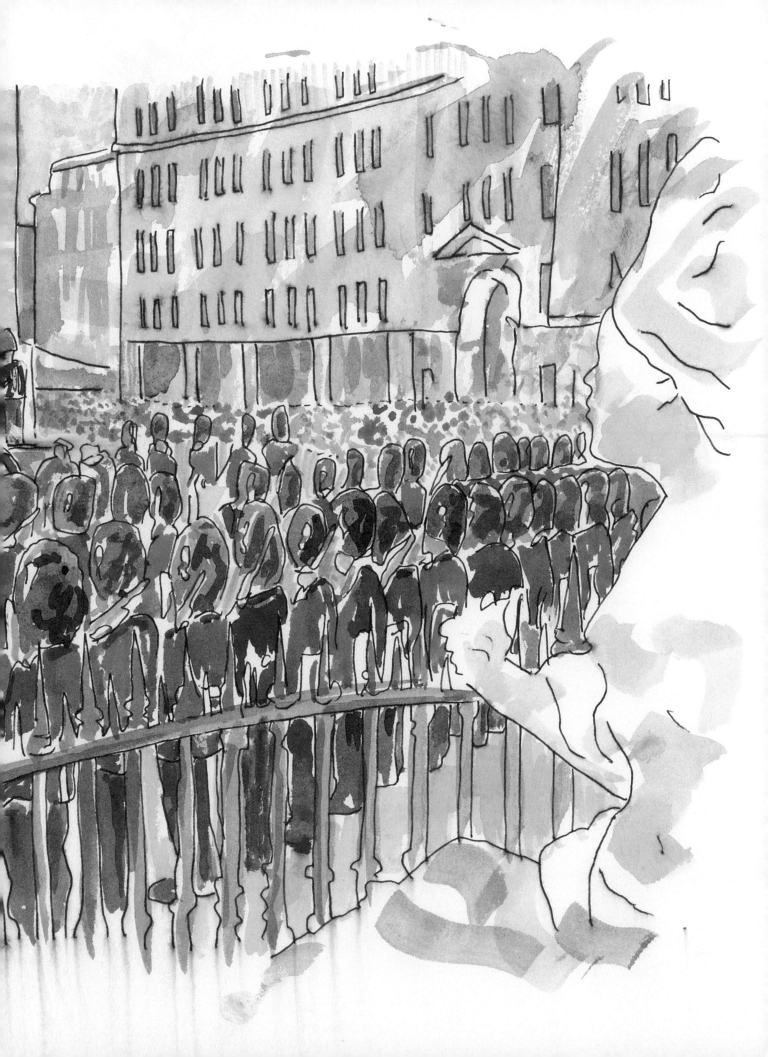

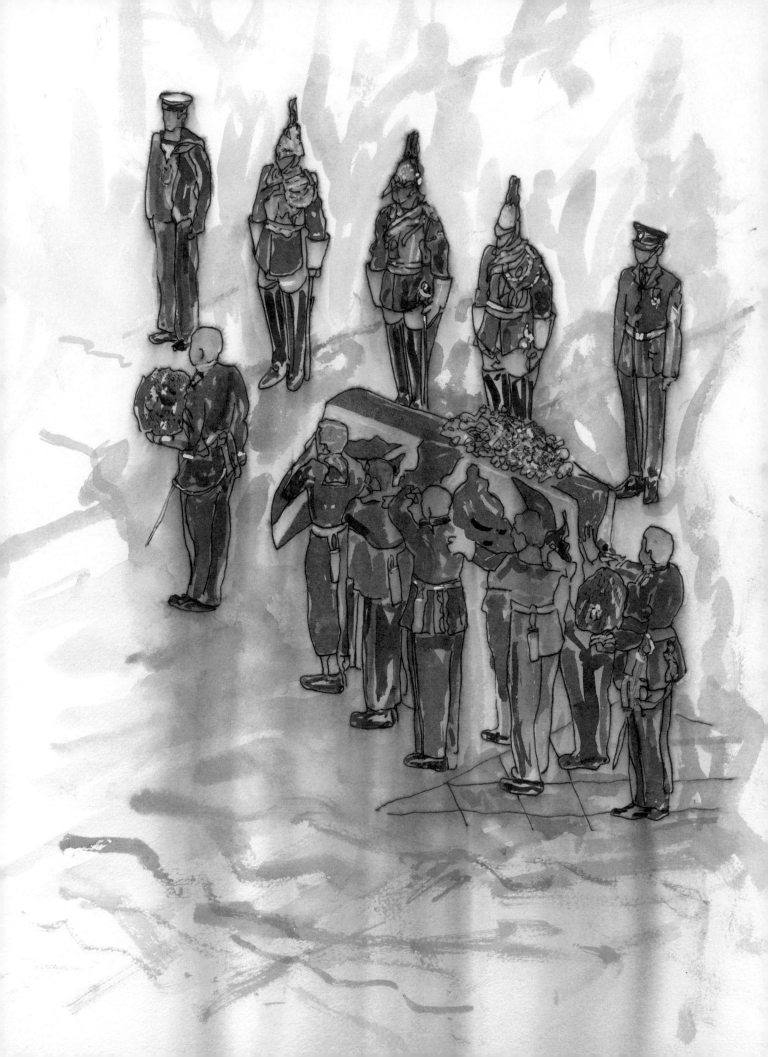

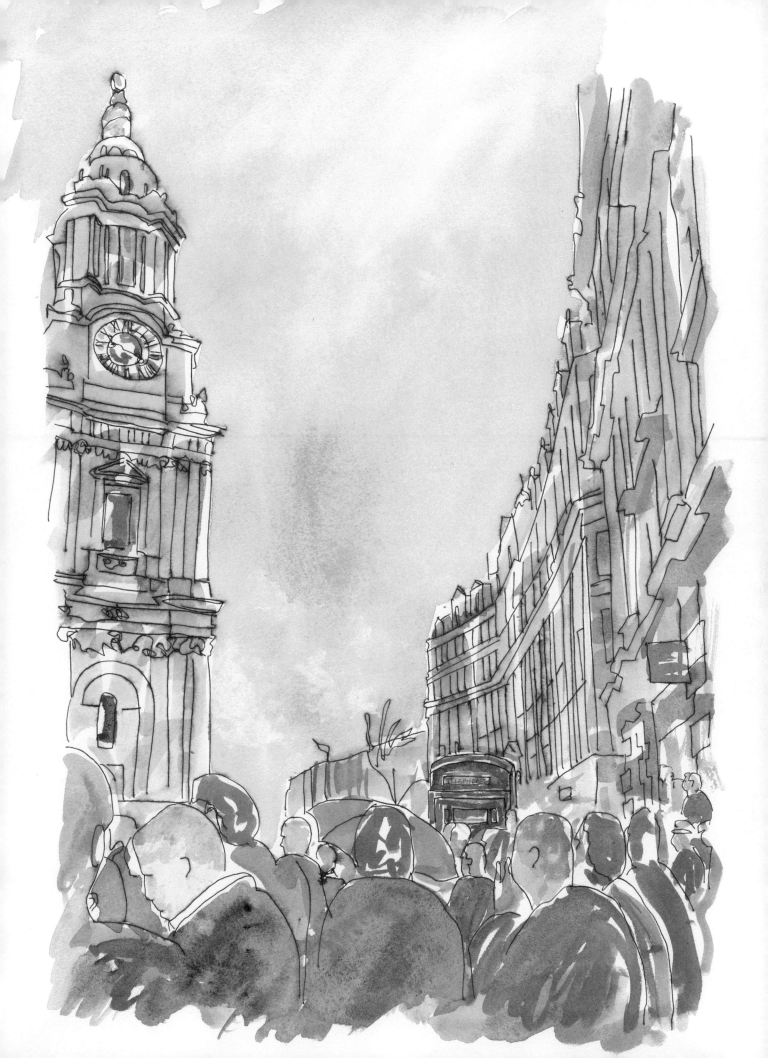

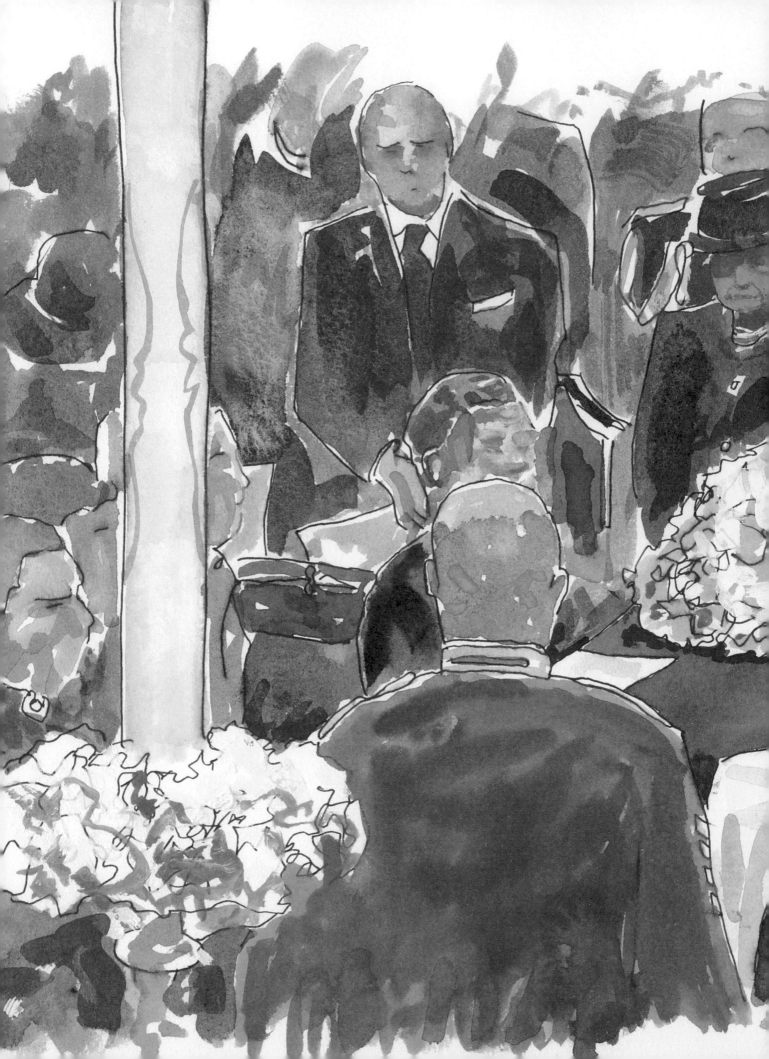

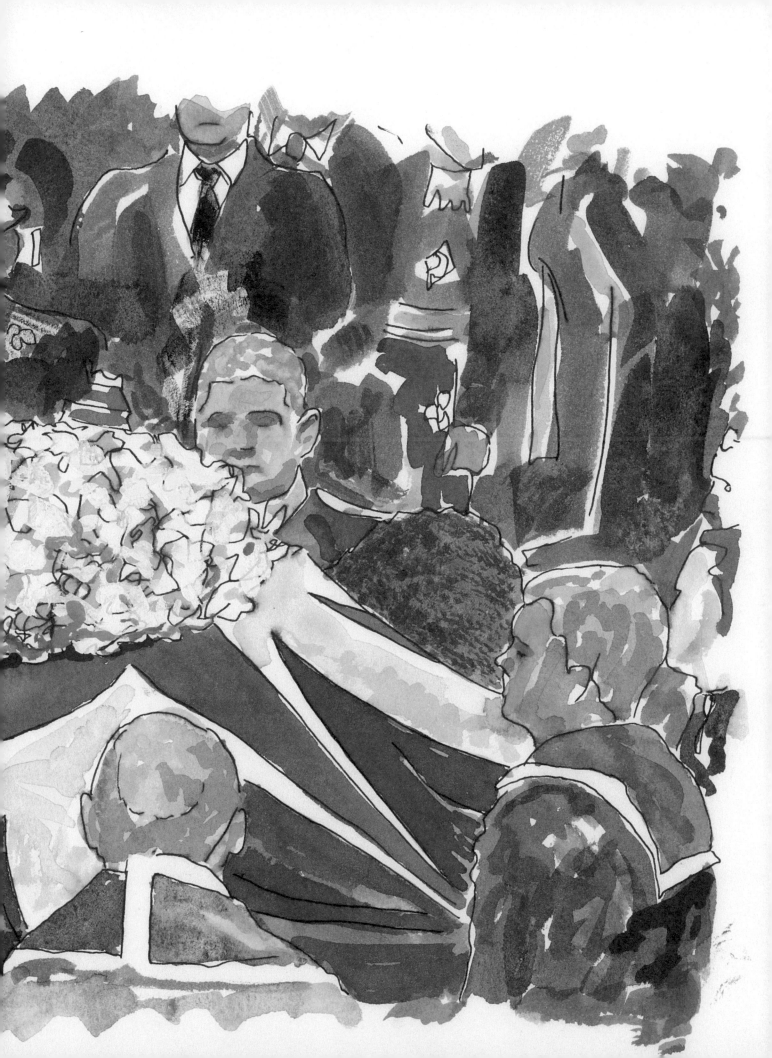

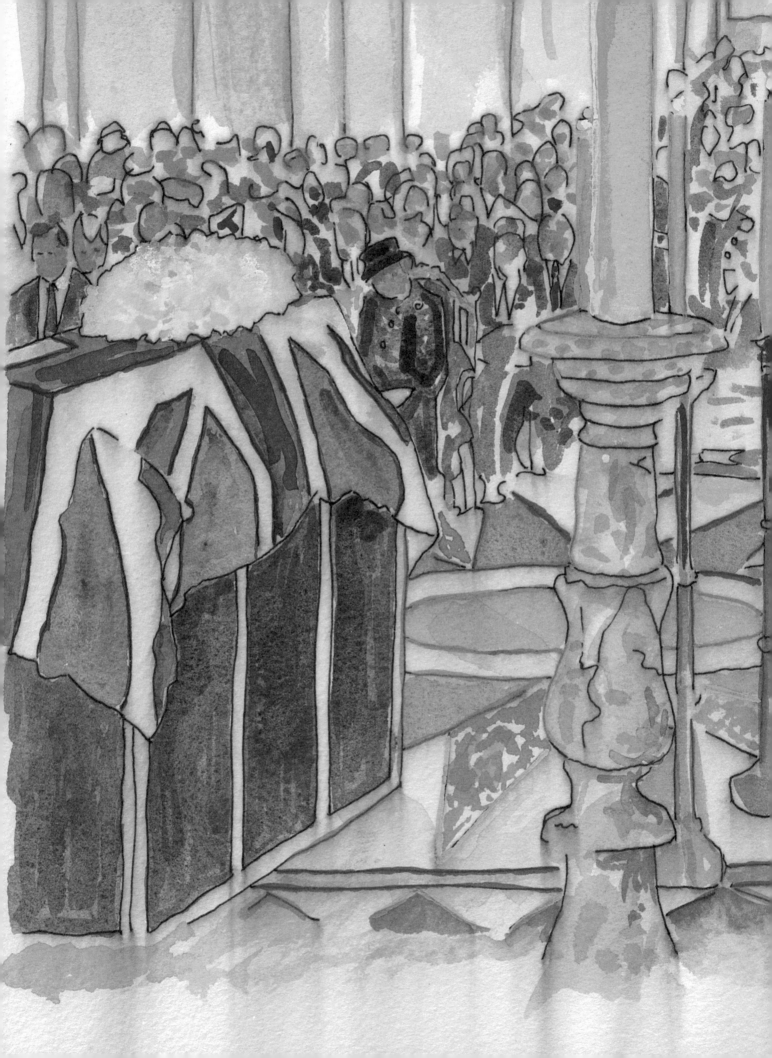

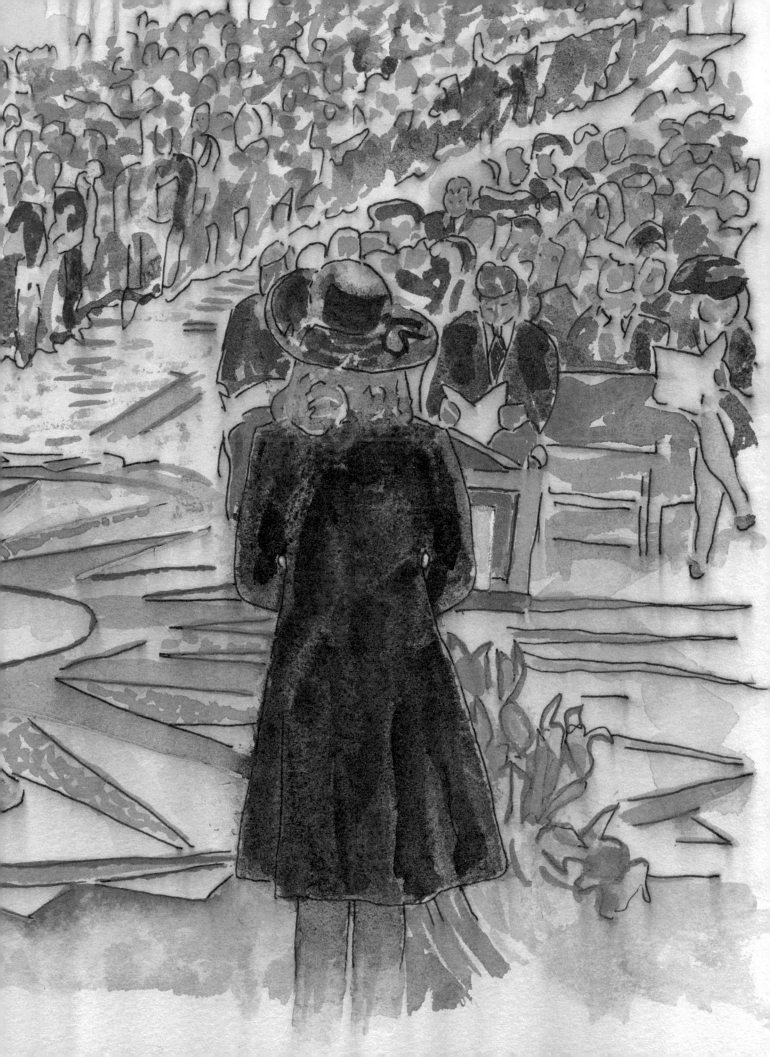

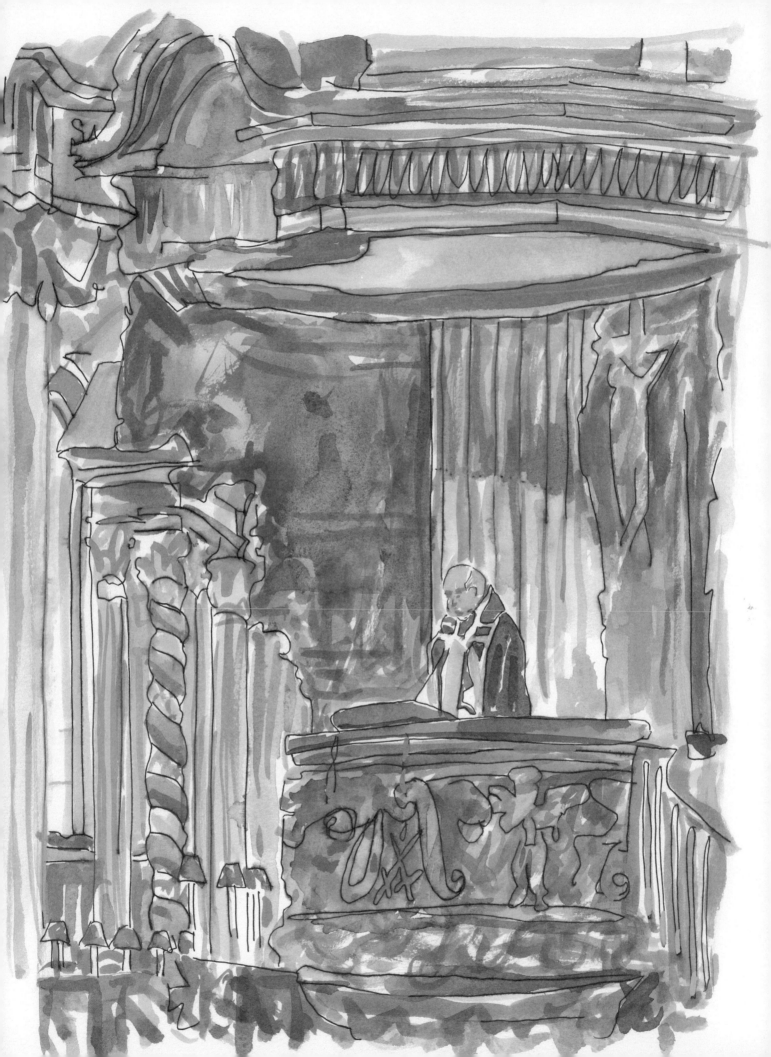

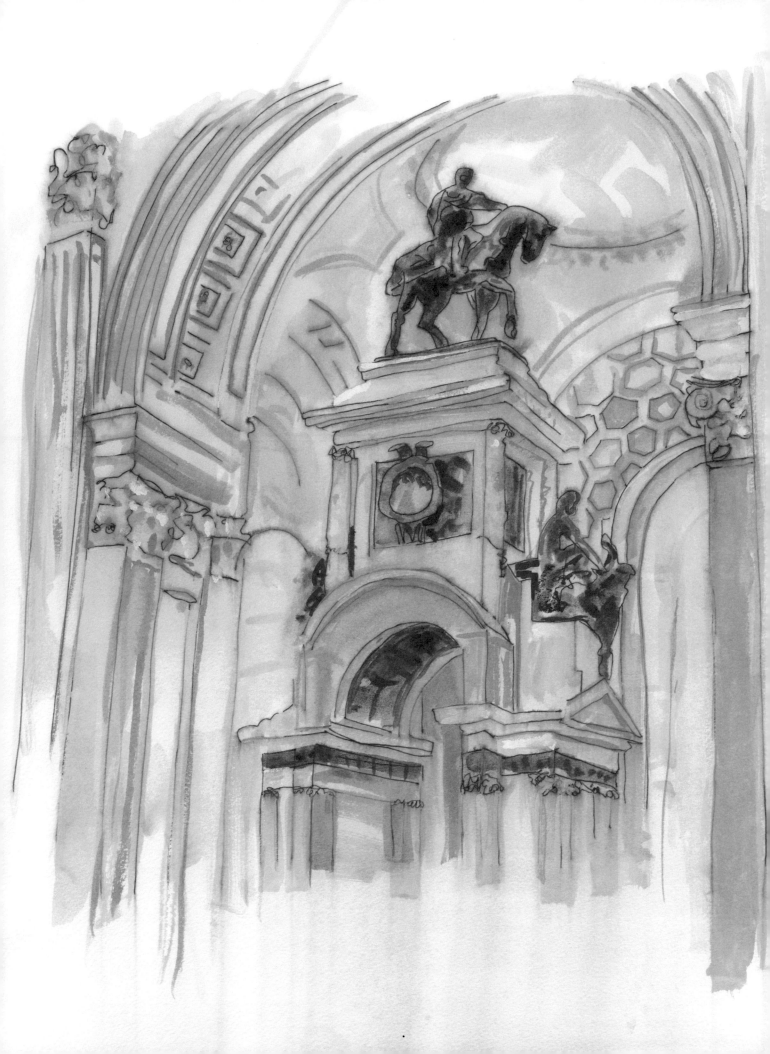

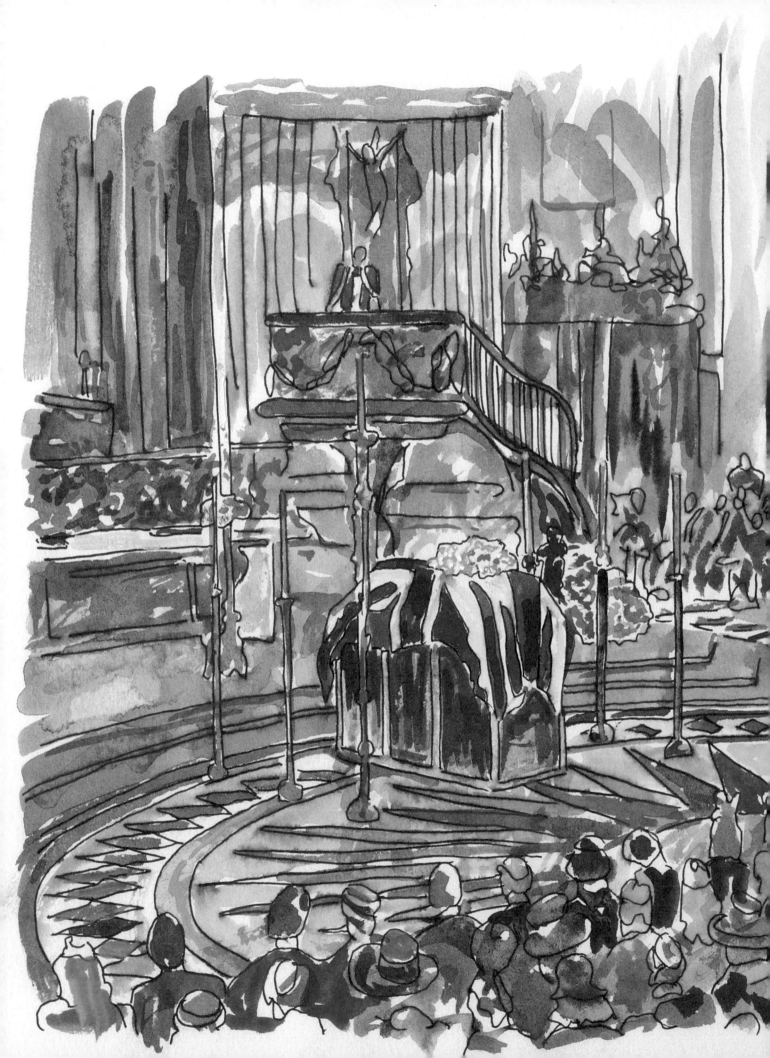

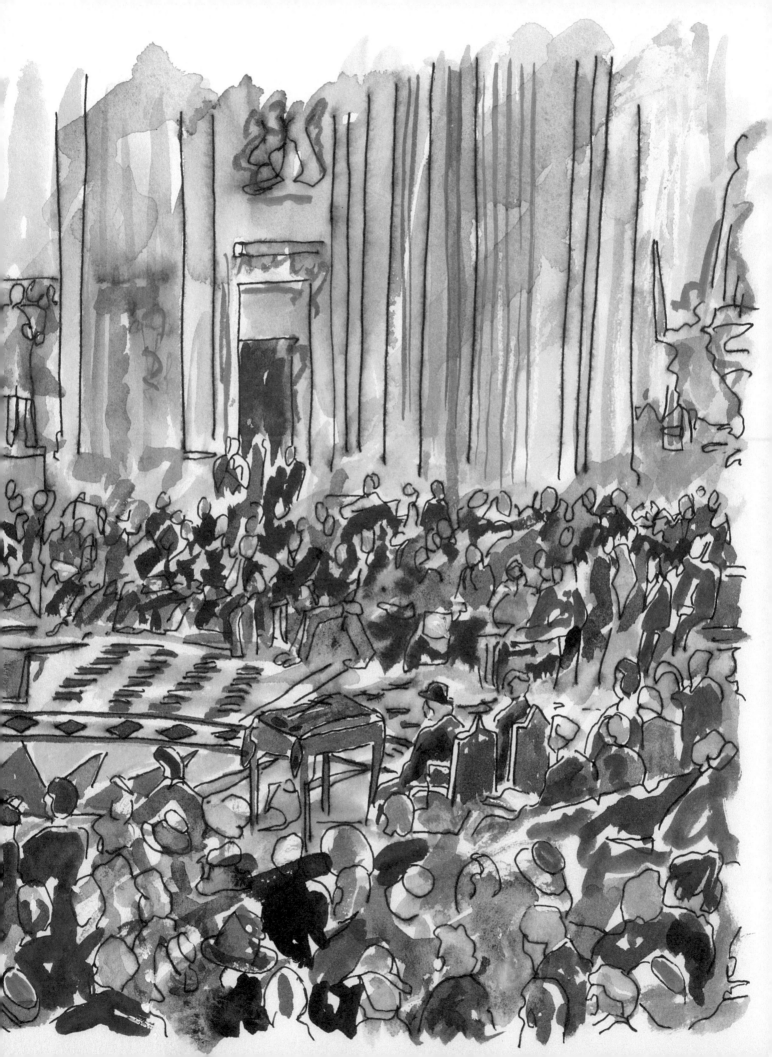

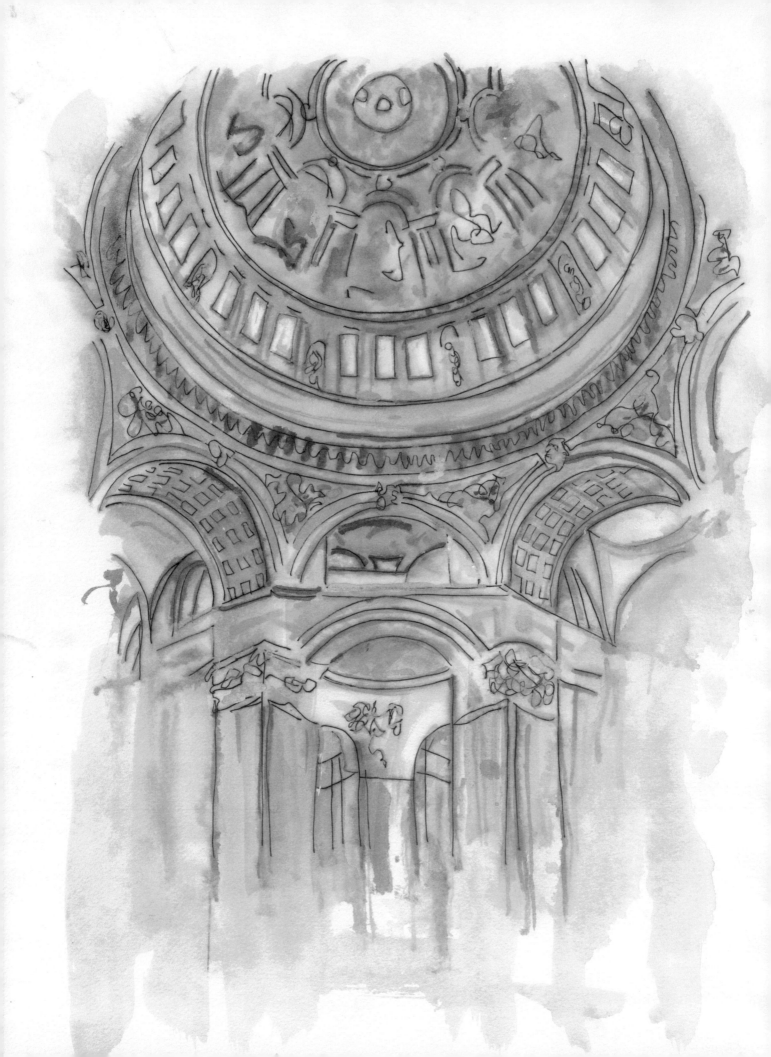

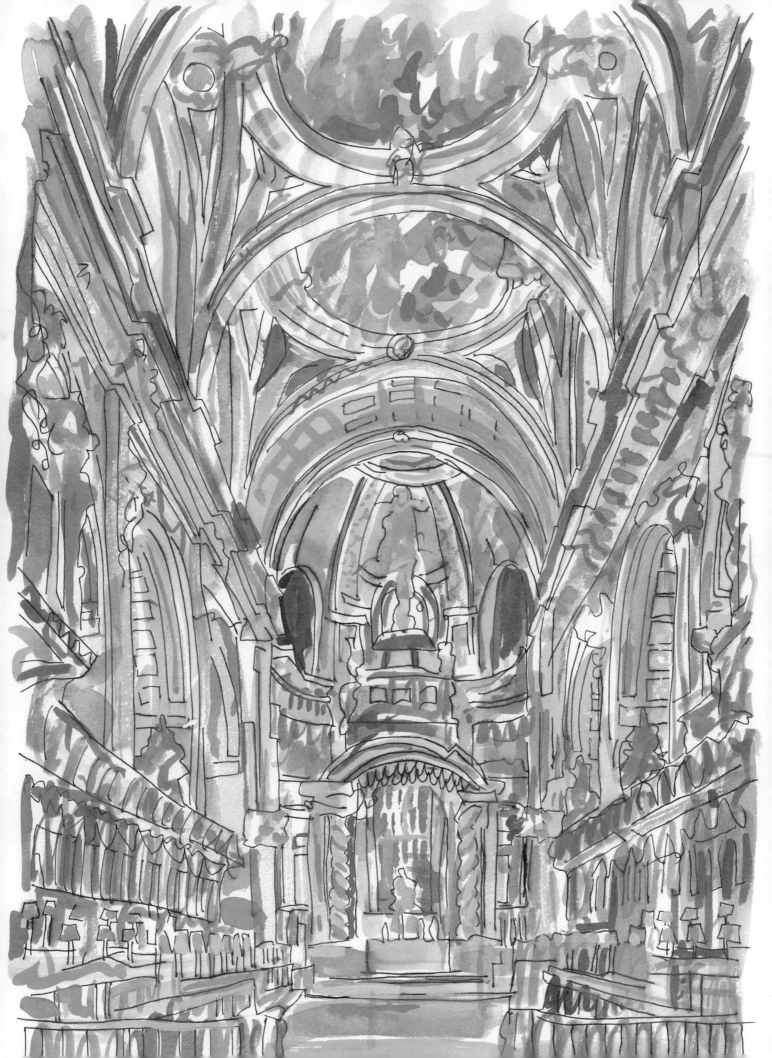

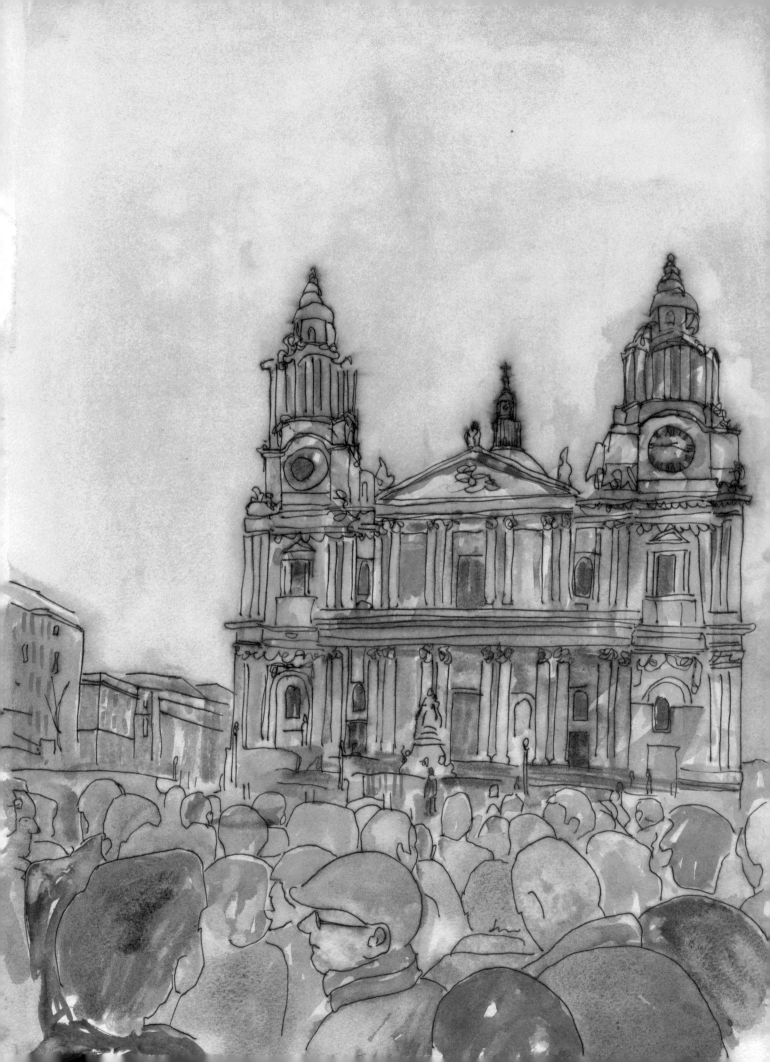

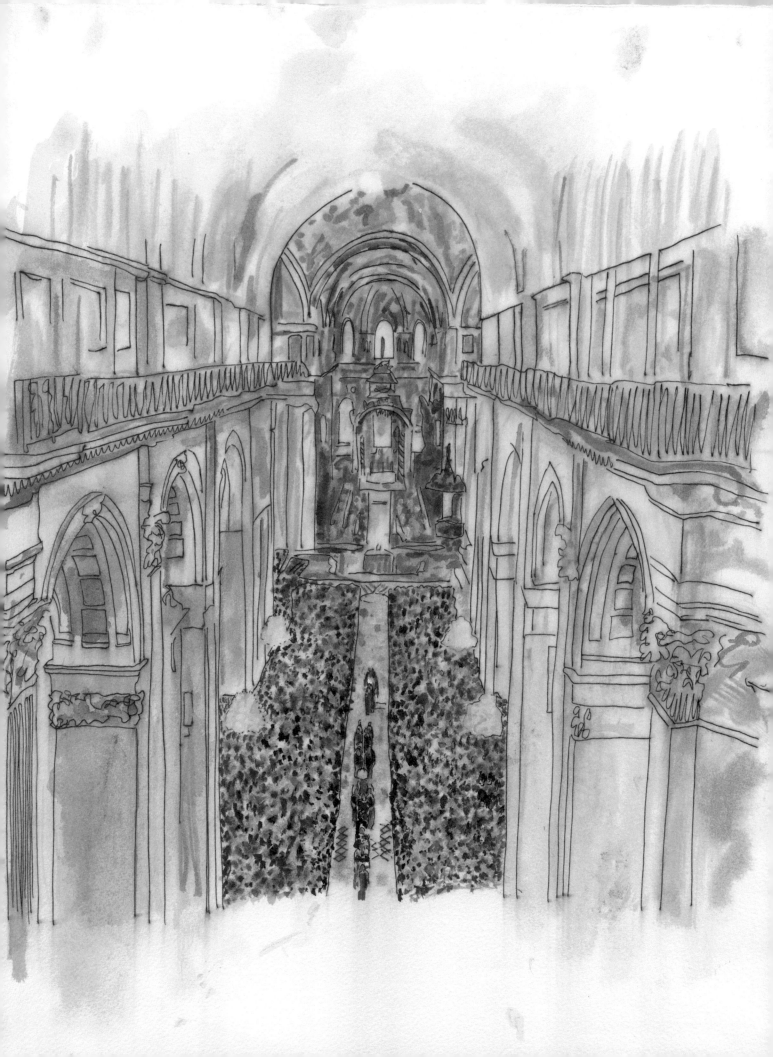

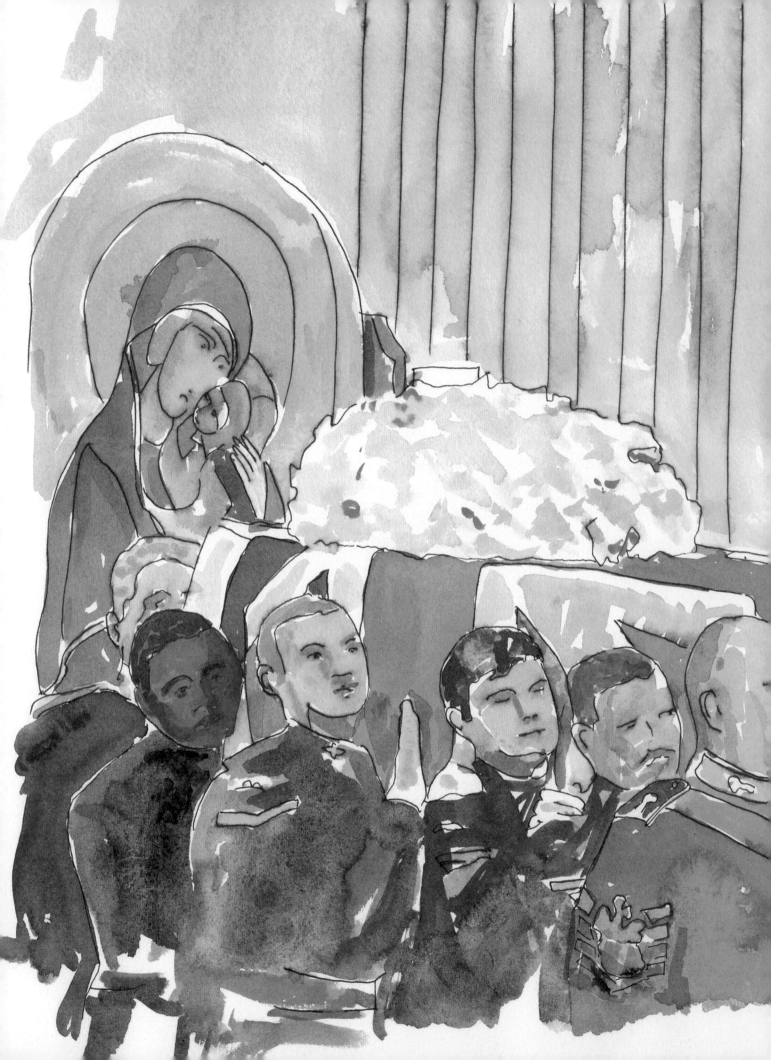

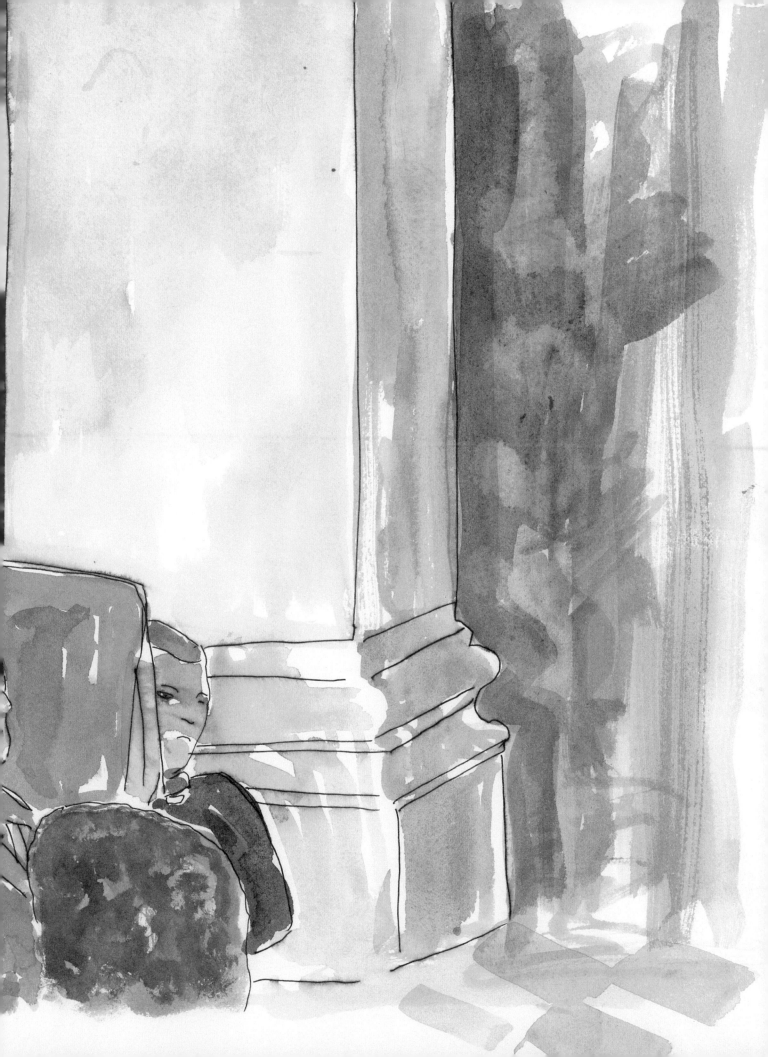

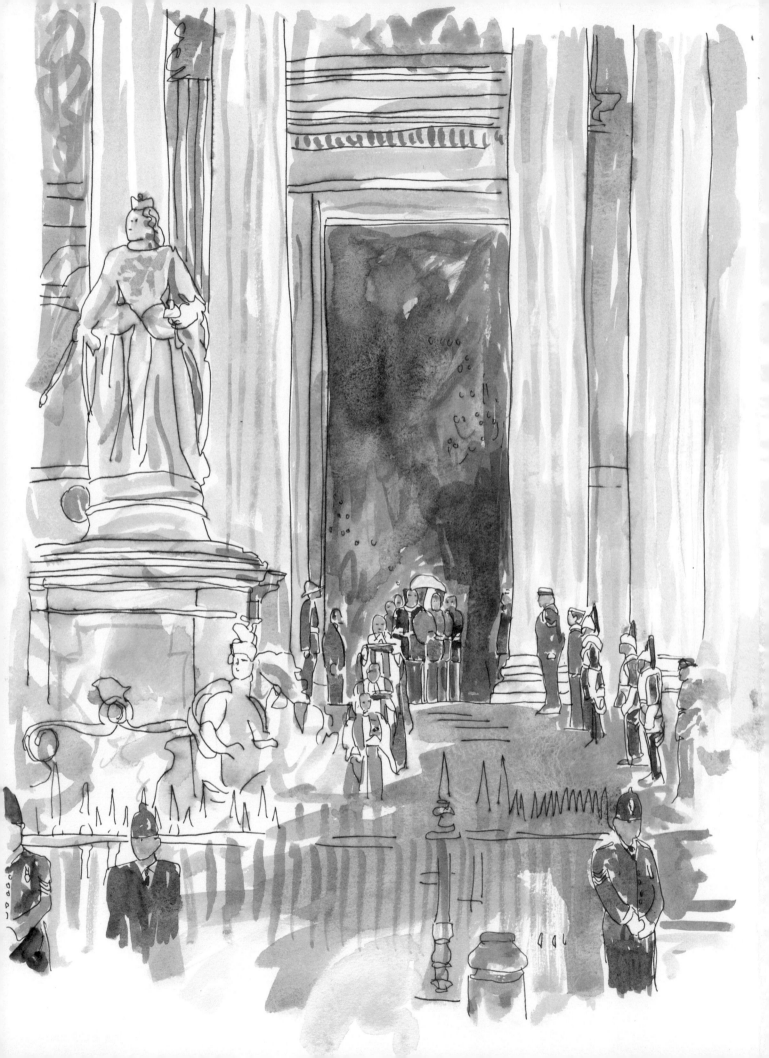